Drawing Out Your Soul

The Touch Drawing
Handbook

Deborah Koff-Chapin
The Center for Touch Drawing
Langley, Washington

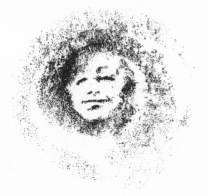

Published by
The Center for Touch Drawing
P.O. Box 914
Langley, WA 98260

Book Design: Will McGreal
Photos: Bill Ruth
Printing: Data Reproductions Corporation

All artwork © Deborah Koff-Chapin unless otherwise specified. Cover image is a full-color Touch Drawing reproduced from *SoulCards* © 1995.

Publisher's Cataloging in Publication
(Prepared by Quality Books Inc.)

 Koff-Chapin, Deborah, 1952-
 Drawing out your soul : the touch drawing handbook / Deborah Koff-Chapin. — 1st ed.
 p. cm.
 LCCN: 96-96108
 ISBN 0-9645623-2-4
 1. Self-perception. 2. Drawing–Therapeutic use. 3. Drawing–Psychological aspects. 4. Projective techniques. I. Title.

BF697.5.S43K64 1996 155.2
 QBI96-20292

Printed in the United States of America on acid free, recycled paper.

Contents

Thank you to all the people who have understood and played a part in the development of Touch Drawing through the years, especially Joe Campagna, Jerry Wennstrom, Benno Kennedy, Gloria Simoneaux, Elizabeth Cogburn, Jean Houston, Hilda Brown, my parents, sisters and their families, Marcia Lauck, Ellias and Theanna Lonsdale, Jeri and Nancy of *In Her Image Gallery*, Gaielle Fleming, Emily Day and my island community. My husband Ross has been an everpresent pillar of support; my daughter Aleah a joy and inspiration. Thanks to Jeanette Arnold, Gregg Garbarino, Lucinda and Eliza Herring, Brendan Whyte and Aleah Chapin for being willing to draw in front of the camera. Thank you to Vince Wray for early design work, Bill Ruth for all the photographs, and Cynthia Patereau for editing. Thanks to Cat Saunders, Autumn Preble, and the other Touch Drawing students who allowed me to reproduce their work. How can I thank Will McGreal enough? I couldn't have pulled this book together without his design, vision, enthusiasm, and caring. Deepest thanks to the *Guiding Spirit of Touch Drawing*, whose gifts are greater than I know.

Deborah Koff-Chapin, artist, teacher and founder of The Center for Touch Drawing, has been developing the process of Touch Drawing since she discovered it in revelatory play in 1974. She received her BFA from Cooper Union in New York that same year. Deborah is creator and publisher of *Soul Cards*, a deck of 60 full-color Touch Drawings. Her artwork and writing have been featured in numerous magazines and in the book *At The Pool Of Wonder*. She has developed transformational images for corporations such as Boeing and Hewlett Packard. Deborah has taught Touch Drawing at numerous national conferences and graduate psychology programs. She has also produced video and audio tapes as educational resources to complement *Drawing Out Your Soul.*

May the spirit
that has given birth
to the process of Touch Drawing
come through the pages of this book
and guide you into your own
dynamic and fulfilling experience.

May the process
of Touch Drawing
be seeded into the lives of others
through your heartfelt sharing.

May Touch Drawing
serve the healing and creative emergence
of all who are drawn
to experience it.

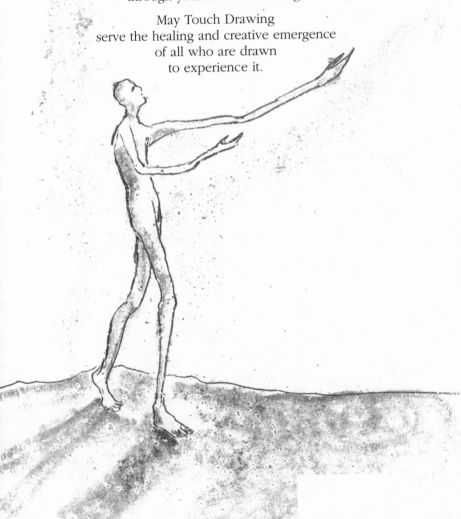

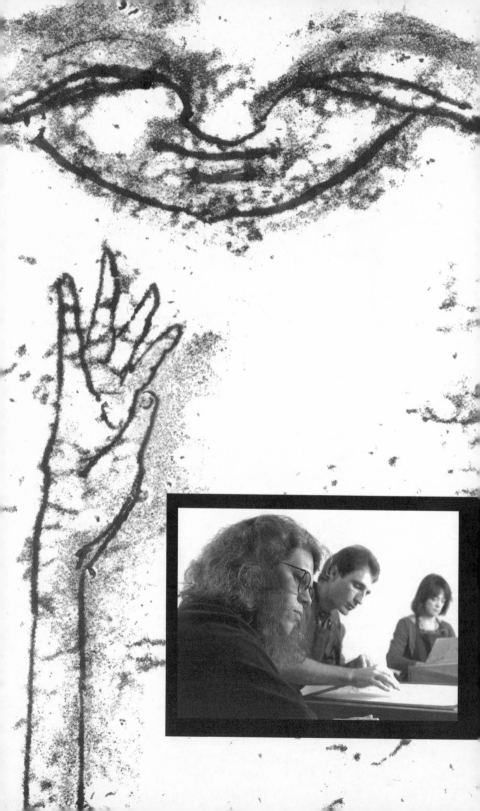

A Call to Practitioners

Touch Drawing is a simple yet profound process. In the technique, a smooth surface is covered with a layer of paint. A sheet of paper is placed over the paint. Wherever the paper is touched, an imprint is made on the back side. Impulses from within take form on paper through the touch of the fingertips. A multitude of drawings can be created in one sitting, each a stepping stone to the next, guiding one deeper into the self. The process is both therapeutic and meditative. Touch Drawing can be practiced by anyone who wishes to explore their soul, regardless of artistic skill or experience.

As I have taught Touch Drawing through the years, I have seen how natural and accessible a medium it is. When given the materials, basic instructions and a safe, supportive environment, people seem to take to Touch Drawing like fish to water. Effortlessly, unerringly, their hands sweep across the surface of the paper, translating their impulses into form and image. The hands are no longer instruments of the mind, inhibited by judgment and fear. They are organic extensions of the soul, moving freely in response to the sensations of the moment.

In a medium as immediate and transparent as Touch Drawing, previously unused channels of expression are opened, enabling uncensored

feelings to flow forth. The act of *creating* with these feelings provides more than a purely cathartic release. It unleashes vibrant healing forces which guide the psyche toward coherence. Whatever darkness or pain may surface is fuel for the creative fire. As this fire burns, layer after layer is revealed, pouring forth through the fingertips and onto the page. With these imprints of the soul now on paper, non-verbal messages from the psyche

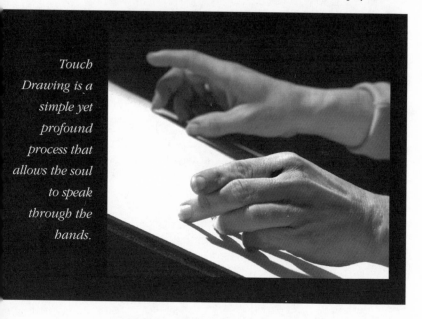

Touch Drawing is a simple yet profound process that allows the soul to speak through the hands.

are available for reflection by the conscious mind. Touch Drawing is a practice of creative, psychological and spiritual integration.

To you who hear the call, I offer Touch Drawing. Use it to delve into your depths and rise to your heights. Feel free to share it with others. Explore how Touch Drawing can be a part of your life work and relationships.

What I share in this handbook is merely a starting point. Take it where your own path leads you. My vision is that Touch Drawing becomes rooted in many facets of human culture through

the natural seeding of person-to-person contact. My hope and prayer is that Touch Drawing can serve in the healing and blossoming of the human soul. I invite you to help make this a reality. The future use and development of Touch Drawing is in your hands.

Take the process into yourself and let your self shine through!

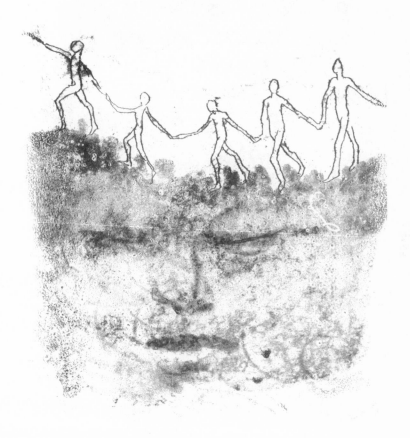

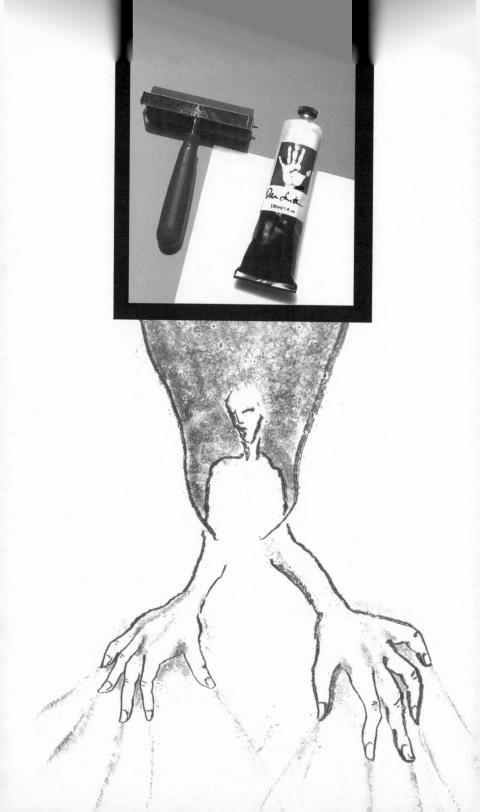

Materials for Touch Drawing

These are the basic materials you need to do Touch Drawing. A simple set of materials can be ordered through The Center for Touch Drawing. See pages 47-48 for more information.

- Tube of oil paint or printmaking ink

- Soft rubber printing roller

- A piece of glass, plastic or any smooth, non-absorbent surface to be used as a drawing board.

- Enough lightweight paper to allow you to draw freely.

Paint
Any oil paint will work. Student grade paints in large tubes are the most economical. Printing ink will create longer lasting artwork if used on acid free paper. It is stiffer than oil paint, and therefore takes more effort to roll out. Oil-based block printing ink is the easiest of these to handle. Do not use acrylic paints! They look like oil paints but dry much faster. The paper will stick to the paint.

Roller
A printmaking roller, called a brayer, is available through art supply stores.

Board

A smooth non-absorbent surface such as glass, plastic laminate or plexiglas will do. It should be slightly larger than the paper you will use. If you use glass, protect yourself from getting cut by either sanding the edges or covering them with tape. Plate glass is heavy but less likely to break.

The least expensive material is available only in large sheets. This is practical if you want a quantity of boards for working with groups of people or multiple colors. It is one-eighth inch thick *panel board* (a composite board covered with a layer of plastic, used for shower stalls and dry-erase markers). A 4' x 8' sheet can be cut into 10 or 12 drawing boards. All of these materials should be available at lumberyards.

Paper

Any paper will work, though light-weight stock is preferable—freezer paper, butcher paper, medical table paper, newsprint, onion skin, typing paper, sumi paper. For longer-lasting drawings, use a higher quality paper. Architectural drafting vellum, light-weight rag bond or 100% rag translucent marker paper, and fine rice papers are good.

The most economical paper is *wrapping tissue*, available in packages of 1000 sheets. You will find it in paper supply warehouses (look under Paper Supplies in the Yellow Pages). To make delicate tissue paper drawings strong and long-lasting, mount them on a heavier paper (mat, poster, or Bristol board). To do this, brush a coat of clear acrylic paint medium onto the paper board. Gently lay the tissue paper on the wet paint, and press from the center out to smooth bubbles. Then brush another coat of clear paint medium over the top of the tissue paper drawing. Another way to make any delicate paper more permanent is to have your drawing laminated. Frame and copy shops often have equipment to do this.

Materials for Children

Water-based block printing ink is best for young children. Be careful that the children don't squeeze out too much paint. If you are in a classroom, the ink can be rolled out onto the children's desks and washed off after the drawing session. Clean-up is easier if you use drawing boards.

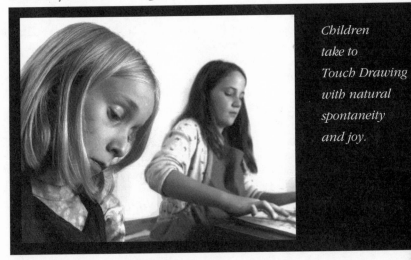

Children take to Touch Drawing with natural spontaneity and joy.

Working with Color

There are several ways to work with color in Touch Drawing. The variations are infinitely open to your exploration. Several drawing boards can be used, each with a different color rolled onto it. A drawing can be moved from board to board while the paint is still wet, creating layers of different colors. A couple of colors can be put on one board, although they will mix together more each time you roll the paint smooth.

Try making abstract washes of color on paper that can be used later as backgrounds upon which to do your Touch Drawings. And of course, you can add color to your drawings after they are dry. Any number of coloring media can work, depend-

ing on the paper you use—pastels, watercolors, acrylics, or colored pencils. If you have mounted a delicate tissue paper drawing as described above, it is now a strong enough surface to work upon with color.

Environment and Set Up

You do not need a special studio to do Touch Drawing. Just try to be in a place where you will not be disturbed. Crack open a window to allow paint fumes to ventilate. You may place the drawing board flat on a table, or lean the top of the board against a table with the bottom edge on your lap. If you would like to sit on the floor in a meditation position, lean the top of the board on a box or piece of furniture, with the bottom of the board in your lap. Some people like to just sit on the floor with the board between their legs. It is advisable to wear old clothes or a smock. You may like to put on some recorded music.

Clean Up

Liquid dish soap does the trick to take paint off your hands and usually takes it off clothing if used immediately. Vegetable oil will dissolve paint as well. Turpentine or mineral spirits are a last resort. Avoid contact with your skin and use with ventilation.

The drawing board and roller can be used countless times without scrubbing off the paint. The leftover paint on the board needs to be rolled smooth after the last drawing. Blot up excess paint by placing a sheet of paper on the board and rubbing on the back of the page. Lift the paper off. If you leave paper on the wet paint, the paper will stick to the board after it dries. If there is excess paint on the roller, roll it off onto a sheet of paper. You may want to allow the board and roller to dry outside or in a garage. This will keep your living

space from smelling like paint. The board develops a natural leathery texture, which is actually more satisfying to work on than a clean board. If the surface becomes too rough for your liking, you can smooth it down with sandpaper.

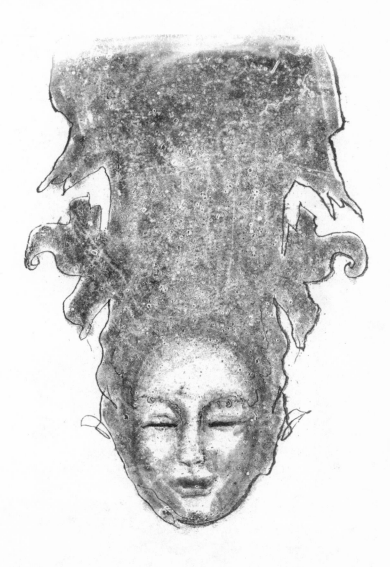

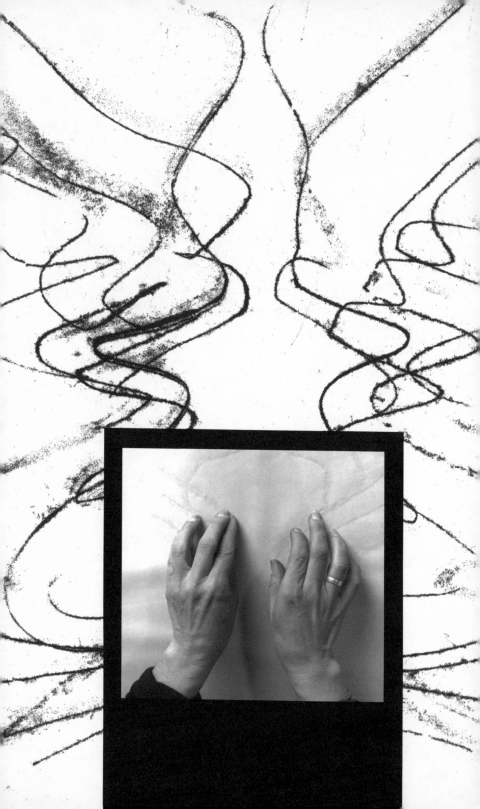

Doing Touch Drawing

You need no artistic skill or even confidence to do Touch Drawing. The most important quality to have is a willingness to *stay with the process* no matter what you are feeling. The speed and directness of Touch Drawing allows you to imprint the sensations of the moment onto the page. No single image is the ultimate statement. Each is a stepping stone guiding you deeper into yourself. You are exploring the unknown–it is here that the treasures of your soul lay waiting. Relax and allow the process to unfold.

You may like to set a regular time to draw, as you would for meditation; or you may like to keep your materials handy for the spontaneous moment of inspiration. Just remember that you don't have to make a production of sitting down to draw. Allow Touch Drawing to be a natural part of your life.

Preparing the Board

Put some thin dabs of paint on the drawing board. Roll the paint until you have an overall, smooth thin layer on the board. Place a sheet of paper on top of the paint. If you have put on too much paint, the paper will begin absorbing paint on contact. If this is the case, rub your hands all over the sheet to blot off the excess paint. Then put on a fresh sheet of paper. When you have the correct amount of paint

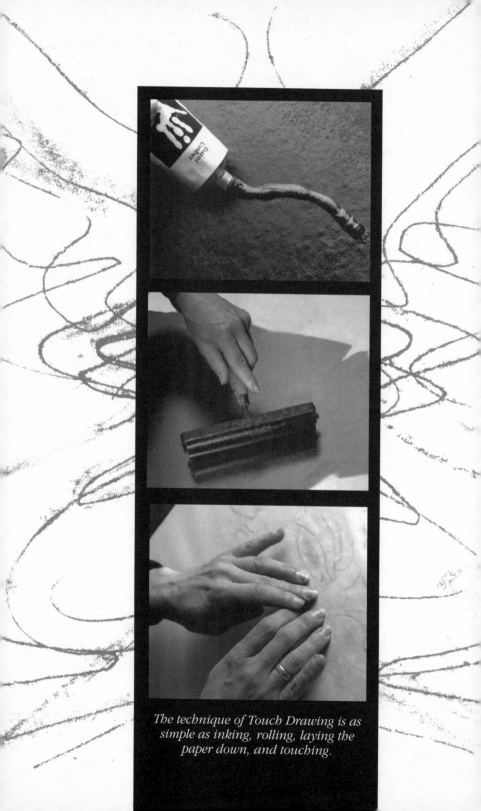

The technique of Touch Drawing is as simple as inking, rolling, laying the paper down, and touching.

on the board, it will take the pressure of your fingertips for the paint to adhere to the paper.

Turning Inward

You may like to take a few moments to center yourself before beginning to draw. Become aware of your body sensations, feelings and thoughts. Accept whatever you are experiencing in the moment as your starting point. In the stillness before you begin drawing, turn to your source of spiritual sustenance and open to receive support.

Beginning to Draw

Close your eyes and move your hands, fingertips and fingernails on the paper. Don't worry about "making a picture". Focus on what it feels like to let your hands dance on the page.

When you have completed one gesture, pull the paper off the board. Barely glance at the image that has appeared on the page. Roll the paint on the board so it is smooth again. Place a fresh sheet of paper on the board. Allow yourself to enter a rhythmic process of moving your hands on the paper, pulling the paper off the board, rolling the paint smooth, putting on fresh paper and touching your hands to the paper again. You do not usually need to add new paint until you have done a few drawings.

As you complete each successive drawing, you can place them one on top of another in a pile. If you have used a thick layer of paint, your drawings may stick together. If this is the case, lay them next to each other until the layer of paint on the board has thinned out.

Try drawing with your non-dominant hand, and with both hands simultaneously. Play with the difference between drawing with your eyes open and your eyes closed. Think of this as a free space in which you can do anything. You are opening

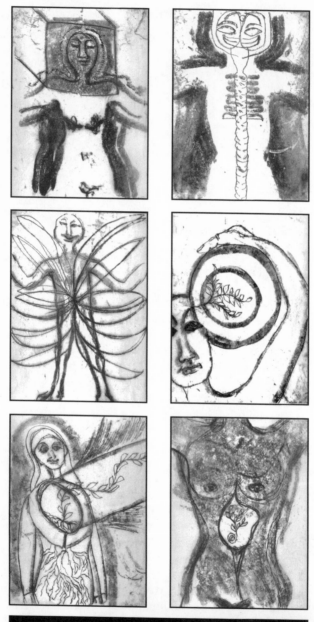

The experience of Touch Drawing grows out of body sensations. Selections from a set by Autumn Preble.

channels of expression that have long been clogged and dusty. Pure, unselfconscious movement clears out these pathways. I once had a student who felt he was just "mushing around" and threw his drawings away. It seemed to him like he had done nothing meaningful during his drawing session. But the following week he found that his poetry writing had been entirely transformed as a result of his Touch Drawing experience.

Body Sensation

The experience of Touch Drawing grows out of body sensations. You may wish to work with the flow of energy, allowing your drawings to take abstract shape and form, as if you are giving a massage or dancing. You can also draw your own body image as you sense it from within. This is very different from drawing an exterior model. In this kinesthetic approach, expressive distortions may appear in the form. Allow your body to speak for itself. Begin to sense how fluid your interior image can be, as your state of being shifts from moment to moment.

As you peer down the corridors of your psyche through the doorway of your body, other shapes, forms, symbols, creatures or characters may emerge onto the page. At times you may just gaze at the paper on the board and *see* an image in a wrinkle of the paper or bits of paint that are showing through. It may begin to feel as if an image already exists and you are just tracing it onto the page. Keep your focus in the moment and your inner knowledge will guide you, allowing the most appropriate images to emerge.

If at any time you feel stuck, draw what *that* feels like. When you *create with* your feelings, they will no longer block you. You will release them and move on to the next stage of your process. Be open to the unknown.

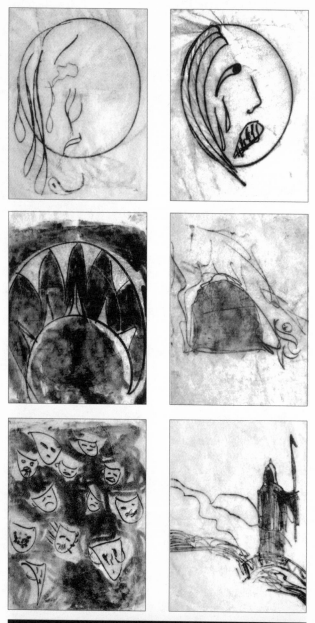

Touch Drawing taps mythic levels of the psyche.
Selections by an anonymous student.

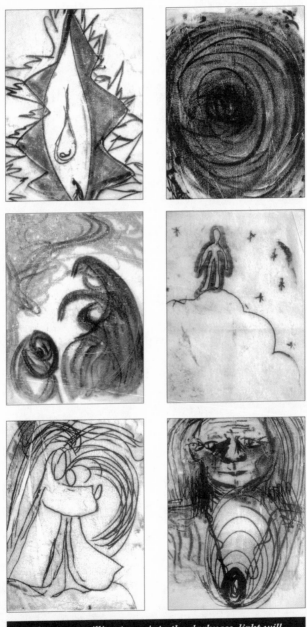

If you are willing to go into the darkness, light will naturally emerge. Selections from another student.

23

The Inner Face

The face is the "mandala" of Touch Drawing. It is a form that you can return to again and again, always the same yet always new. Bring your awareness to your face, and have each hand trace one hemisphere onto the page. Be guided by the inner sensations, rather than your idea of how a face should be drawn. Try doing a number of faces, some with your eyes closed and some with eyes open. Imagine that the drawing board is an inner mirror; each face that you draw leading you deeper into your self. You may begin to feel as if these faces have a life of their own, as you allow a deep presence from within to take form.

Stay With It

In most introductory workshops, we draw continuously for at least 90 minutes. Staying with the process even when it feels uncomfortable allows the inner work of Touch Drawing to unfold. If you hate your drawings or feel stuck, draw what this feels like. Scratch up a sheet of paper if you want to. If you become afraid of what is emerging, give form to the fear. If you are finding the experience ecstatically joyful, let the feeling of joy flow out your fingertips and onto the page. Accept your feelings, *whatever* they may be, and translate them onto the paper. If you are doing this, you are truly doing Touch Drawing.

Try to discern the difference between *avoidance* and *completion*. When you are complete, you should have

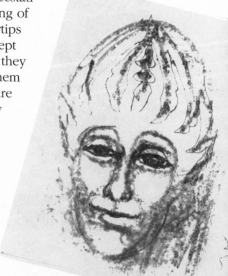

a sense of stability, wholeness, stillness or satisfaction. You may even feel emptied out or tired, as if you have just had an inner workout. When you have closed the drawing session, be sure to roll the leftover paint on your board smooth so that it is a good, flat surface for future Touch Drawing.

Integrating Your Images

Having completed a session of Touch Drawing, another process begins; integrating the images into your life. This can be a private or a shared experience. It is an opportunity to develop a relationship with images that have arisen from the depths of your psyche.

After you have completed a series, take your pile of drawings and turn them

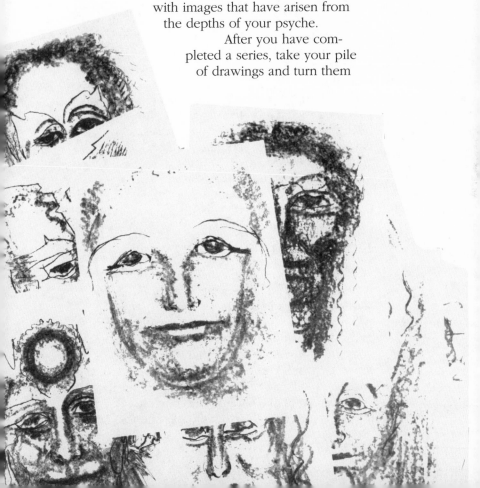

over, so the first one is on top. Look at them in the order in which they were created, as if you were turning the pages of a book.

See the drawings as imprints of your psyche on the page. One natural way to relate to your images is to engage in "imaginal dialogue" with them. Select a drawing that is particularly intriguing to you. Spend some time gazing at it without trying to interpret its meaning. Just as a photograph is a picture of a living being, imagine that the shapes and forms on the page represent some living force in your psyche.

You may like to ask a question of the image; for example, "What challenge do you offer?" or "What gift do bring?" Perhaps you would like to tell a story about your drawing or series of drawings. Begin with "Once upon a time..." and see what happens. You can use your Touch Drawings as inspiration for creating in other expressive modalities: music, movement or poetry can arise from reflecting on your images. (See the *SoulCards Manual* for guidance–the instructions provided can be applied equally well to your own drawings.) It is helpful to number and date each series. This way the drawings can act as a visual journal. When you look at your drawings again at a later time, you will find there is more in them than you could appreciate at the time they were created.

Drawing With Others

Sharing the process with others can enrich your experience of Touch Drawing. It can be helpful to set up a regular time, either weekly or monthly, when you meet with a friend or a small group to draw. A regular appointment creates the space in your life that you may not otherwise set aside for drawing. When you gather, give each other a few minutes to talk about current issues in your lives.

Once you have entered the drawing time, allow each person their private experience. The

support of the group will allow each of you to go more deeply into yourselves. Drawing is a wonderful way to be together without having to verbalize continually.

After you have all completed your drawings, give each person time to share their images and reflect on their experience. Up to six people can comfortably witness each others drawings in one sitting. This is a *very* important part of the process. As you look through the drawings together, be aware that you are revealing your inner journeys to one another. Treat this time of sharing as a sacred

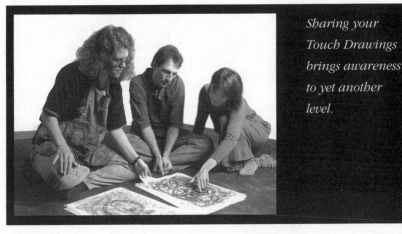

Sharing your Touch Drawings brings awareness to yet another level.

trust. Be careful not to judge the images as "art" or to project your own interpretation on someone else's image. As you honor another's drawings and experience, you will come to honor and appreciate your own. If a group continues drawing together over a period of time, a great bond will be formed.

Inner Portraits

Once you have developed a sense of connection to yourself through Touch Drawing, you may like to explore your connection to others through *Inner Portraits*. Sit face to face with the person you wish to draw. Light a candle or in some way invoke a

sacred space. State your intention to create images of particular significance to your partner. Spend a few minutes gazing at one another with slightly unfocused eyes. Allow the boundaries between you to soften. Relax and be in one another's presence for a time. When you feel an impulse rising from within, begin to draw. Do your best not to let your mind censor or direct the drawing process. As images emerge onto the page, try not to think of their meaning for the other person. Even if they seem silly or irrelevant, trust that a greater knowledge is guiding you. When you feel complete, look through the drawings together and reflect upon their significance. You may be surprised at the wisdom that has come through your hands. This is a great practice in opening your intuitive faculties.

Drawing in the Natural Environment

Touch Drawing is a wonderful medium for connecting with the spirit of nature. To set up your materials for working out of doors you need a few extra things. Make a portfolio to hold paper and drawing board by taping two pieces of cardboard together along one side. Carry your roller, paint and a rag in a backpack or shoulder bag. A couple of

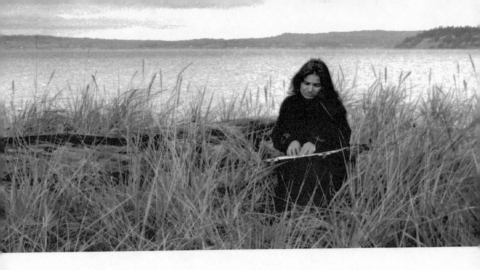

large clips will secure the paper to the board if it is breezy. You may like to bring a cushion to sit on.

On a gentle walk or longer hike, find a special spot, preferably out of the wind. Take some time to slow down by meditating, taking a nap, or just sit quietly for a while. When you feel you have "arrived", prepare your materials for drawing. A log or other outcropping can be used to prop up your drawing board. In Touch Drawing, the intention is to draw your relationship with the natural world, rather than literally sketching the landscape. Just let the spirit of the place have its impact on your psyche, and draw whatever comes to you. Allow the separation between yourself and the place to dissolve. When you look at your drawings later, you will more fully appreciate the depth of your communion.

Concert, Lecture or Poetry Reading

Touch Drawing can add another dimension to your experience of a concert, lecture or poetry reading. It will help to make arrangements to sit in a place where you won't distract anybody. Someplace off to the side or in the back will do. You do not need to be able to see the presentation; you only need to hear it.

As you take in the music or words, draw what comes to you in response. To listen and create simultaneously puts you into a highly focused state. The experience of moving the content through your body and out into tangible form creates a greater integration of the subject matter. When you look at your drawings, you will find that you have a visual journal of the event. The images will help you recall both the content and feeling tones of the presentation.

Therapeutic Applications

Touch Drawing is a powerful therapeutic tool. As a therapist, body worker, or healer, you can keep materials in your office for use by your clients at appropriate times. Touch Drawing is a way to move beyond conditioned patterns and allow subconscious images to emerge. It can be used to either catalyze or integrate an experience. The drawings can then be reflected upon and the images be brought to consciousness.

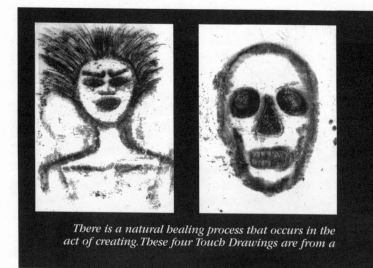

There is a natural healing process that occurs in the act of creating. These four Touch Drawings are from a

Touch Drawing can be particularly powerful for people dealing with body-based trauma, such as sexual abuse. In Touch Drawing, the body is free to speak directly for itself. Touch Drawing also makes visual expression available to people who are unable to handle tools, such as the arthritic or those who are healing from stroke.

There are potential applications for work with autistic children, learning disabled, the blind and deaf. Touch Drawing can be used in conjunction with numerous therapeutic forms, such as Voice Dialogue, Guided Imagery and Music, Psychosynthesis, Movement, Drama and Music Therapy and Dreamwork. If you feel a spark of inspiration about how to apply Touch Drawing in your own life work, by all means, fan the flames!

Teaching Touch Drawing to Others

When I first discovered Touch Drawing, I knew that it was being revealed for more than my own personal use. In those moments I received a

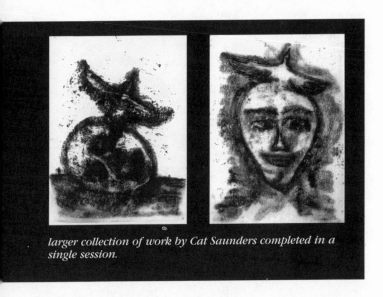

larger collection of work by Cat Saunders completed in a single session.

calling to share the gift of Touch Drawing. As this gift was freely given to me, I offer it freely to you. There is no certification required to use Touch Drawing professionally. But before you teach others, you must have a strong enough experience with it yourself to be able to transmit both the technique and the spirit.

In terms of the technique, be sure that you are using the correct materials. A little mistake in choice of paint or paper can set your students or clients up for a very frustrating experience. Be responsible for the physical space you are working in. Oil paint is difficult to wash out of a carpet or off furniture. Though Touch Drawing can be done with very little mess, there is often someone in the group who gets paint on their hands or feet. If you are in a space where cleanliness matters, cover sensitive areas with dropcloths. Encourage every-one in the group to be sensitive to the situation.

It is important to create a safe and supportive atmosphere for people doing Touch Drawing. This is not a sketch class! Bring your own unique gifts to the crafting of a sacred space in which people can delve into their depths. In particular, do not allow social talk or looking at each other's draw-ings while they are being created. People need a sense of privacy to explore their souls. You may like to create some simple, meditative music with a drum or other instrument to help hold the space while people draw. Allow enough time for every-one to complete their inner journeys. Be sure to encourage each person to share their drawings after they are done. If you are in a large group, this can happen in clusters of two to four people. It is not uncommon to have someone discount their own drawing experience until they have reflected upon it with another. Sharing stories and insights helps integrate the powerful soulwork that hap-pens while Touch Drawing.

Communicating with The Center for Touch Drawing

Please make the resources of The Center for Touch Drawing available to everyone to whom you introduce the process. If you have powerful personal experiences, or are using Touch Drawing with others in a unique or exciting way, send written material, photos or slides to The Center. Please include a copyright release statement—"I hereby give permission to the The Center for Touch Drawing to publish or in other ways display this material for educational purposes". Sign your name with the date. Your stories and images can then become source material for future books and presentations. We will also be regularly posting material on the Touch Drawing web site. Through the web site, you can become part of a network of support and co-creation. If you contact The Center, we will notify you about workshops in your area. We also envision an annual gathering to meet, share experiences, develop teaching skills and nurture the process in each other. Information about contacting The Center is located on page 47 of this handbook.

Be open to an awareness of a supportive presence that permeates the Touch Drawing experience. To some, this might be identified as an aspect of the self. To others, it may be understood as a spiritual guide. I have come to call this presence "The Guiding Spirit of Touch Drawing." For me, its acknowledgment seems to bring greater depth and coherence to my work, especially when I invoke it at the opening of a Touch Drawing session. I encourage you to develop your own relationship with this subtle yet dynamic presence.

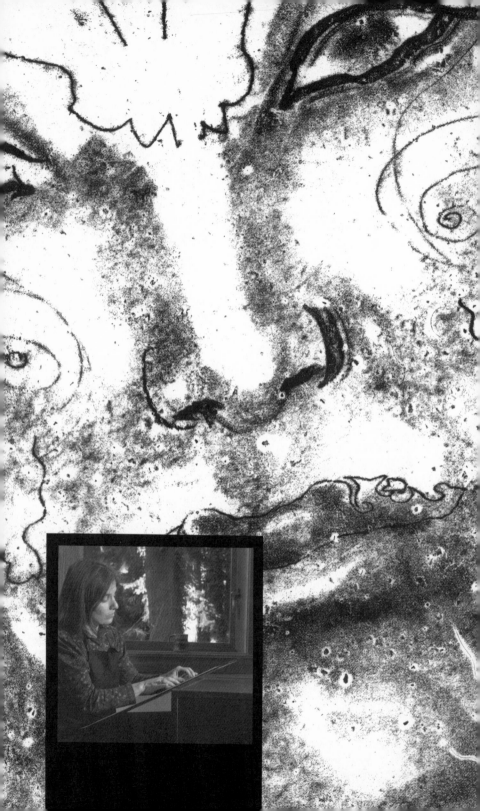

The Story of Touch Drawing

When I was growing up, I held the artist as my highest ideal: In living close to the heart of creation, the artist lifted the veil between the world and its source. For me, to be an artist was to be on a path of truth. The creative process also served as my stabilizing element during the tumultuous upheavals of the sixties. While other teenagers were turning to drugs, politics or parties, painting was my alternative mode of "truth seeking". It was a vehicle for turning inward and realizing the companionship of solitude, as well as a means of communicating from the depths of my soul. My natural tendency was to reflect states of being through human images. Once, frustrated by the authoritarian attitudes at my public high school, I went home and painted a giant red face which filled the canvas and stared out at me with great power and authority. In painting this image, I had found a way to release my anger creatively and make a statement that communicated personal feelings in a universal form. There were other times when I would go into the woods, soak up the peaceful atmosphere and let an image surface into my mind. I would pour this out onto the canvas in one intense stream of effort. It felt as if the image had a life of its own. There was magic in these moments, a feeling of having helped God in the act of creation.

Upon graduating from high school, I leaped into the mystique of the New York City art world. I attended Cooper Union, an art school in the heart of Manhattan. It was here I assumed I'd find comrades in the passionate search for truth through art. Something in me opened as I strengthened through the independence of city life. Yet something in me closed, as I put up protective shields in the harsh city environment.

Existential nausea set in as I began to question the meaning of art. The human form disappeared from my paintings. Brushes began to feel like obscure instruments, so I turned to pouring and dripping paint. I learned to read art journals and verbalize the concepts behind the work I saw in contemporary galleries and museums. "Art talk" became the high craft.

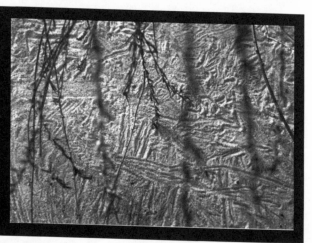

My photograph of the wind and willow branches drawing in the sand. At the time, I was yearning for a more natural way to draw.

During that same time, I occasionally took walks on the country land my school provided for retreats. One day I came across a willow tree swaying gently in the breeze. The tips of its branches were etching lines in the sand below, creating ever-changing patterns on the beach. Ecstatic at the sight, I realized that I was witnessing

the pure, unselfconscious act of Nature drawing. I photographed the branches marking the sand and thought no more of it at the time. In retrospect, I have come to recognize my joy in this experience as a sign of my underlying search for a more natural way to draw.

By the last year of art school, I had become fluent in the language of abstraction. Pure and essential, yes, but foreign to the eyes of all but those educated in the esoteric knowledge of the art world. I was stunned into this realization one day when an old friend came to my studio and stared blankly at the abstract paintings on the wall. I used to share the depths of my soul with friends through imagery. Where had I gone in those years to draw such a blank? The seed of an answer came one day as I scribbled some words onto a page... "What's wrong with drawing a face?" With a shudder of guilt, I tentatively doodled some raw, primitive heads. It felt as if as if I was drawing something "dirty". I tucked the embarassing doodle away.

Certainly art school had given me the opportunity to draw from models. But I had not been attracted to these classes, where the human figure was studied as empty form. In abstract and conceptual explorations I had found a level of contemplative fulfillment. But the ancient and universal language of the soul as expressed by the human face and figure–how could I have forgotten all these years?

The words that I had scribbled on that page were not only asking a question about art, but about myself: "What's wrong with *showing* a human face?" What had I become in those years in the city; strong, hardened, out for myself? My protective shell began to crack. I began to *see* faces. The city was suddenly filled with them. Eyes looking out from all kinds of bodies; the same eyes, one human soul; something of myself in everyone.

Within several weeks the seed that had been germinating in my being burst forth in the form of Touch Drawing. On the last day of my last year in school, I was helping a friend clean an inked glass plate in the print shop. Before wiping the ink off the plate with a paper towel, I playfully moved my hands over the towel, and lifting it, saw lines which had been transferred to the underside of the towel by my touch. *Lines coming directly from my fingertips!* I laughed hysterically with this discovery and crawled around on the floor, gathering up more discarded paper towels. In a state of ecstatic revelation, flowing lines poured from my hands. Like the willow in the sand, they were a natural extension of my being onto the page, a record of each moment as it passed. Within minutes I was drawing faces with both hands. My ever-changing soul was being reflected before me, childlike and primitive, honest and direct.

Although this experience had the appearance of simply being play, under the surface was something profound and powerful. It was as if I

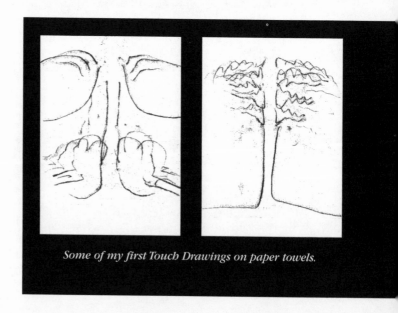

Some of my first Touch Drawings on paper towels.

was receiving a gift from outside of time, from an invisible knowing presence. I had a sense that Touch Drawing was being given not just for myself, but as a gift for humanity. Along with the gift came a responsibility. Somehow, I would have to share this gift with the world.

While sensing that I was acting on behalf of a great evolutionary force, I began to pour my soul into Touch Drawing. It soon became my personal lifeline. During difficult times I would turn to the drawing board to release emotions. As I accepted my feelings and allowed them to pour onto the page directly through my hands, I was drawn more deeply into myself. It was as if I was sculpting my own being; transforming, literally before my own eyes. At the end of a session I had a record of this transformation: images of my soul in motion. And I would feel clear and whole.

The images that emerged in those days were personal and therapeutic. Surrendering to such primal expression taught me the art of listening within. Over time, I began to tap into a

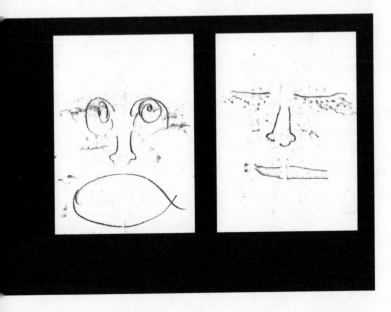

transpersonal consciousness. Gradually, I have become aware of a subtle overlighting presence as I draw. Now when I bring my attention to the drawing board, my hands trace the beginnings of a sensed image. In deep focus and trust, I abandon myself to the process and watch as an image emerges onto the page. When I rise to leave the drawing board, I realize that I am disengaging from a deep communion. Silently, I offer my thanks.

Through the years I have sought to answer the call to share Touch Drawing that came in the initial moments of its discovery. My original intuition that this process was not for myself alone is confirmed again and again. It is confirmed each time I witness people who formerly had been expressing fear and limitation, relax and dive into themselves through the mirror of the drawing board. It is confirmed each time I see hands moving on the page in an unselfconscious dance, and by the healing power that is unleashed through this pure act of creation. And it is confirmed by the deep satisfaction felt as people recognize the honesty, power and beauty reflected in their drawings, each other and themselves.

This handbook is another step towards fulfilling the call to share Touch Drawing. My hope is that Touch Drawing will sprout up in the gardens of so many lives that it will continue to reseed itself long after I am gone. I trust that the Guiding Spirit that brought me to this process will shine on its many tender shoots, supporting them to blossom and grow, each in their own way. May you nurture and care for this gift, be fed by it, and freely share the abundance of your harvest. And may you plant new seeds for the future so that the living spirit of Touch Drawing will continue to grow.

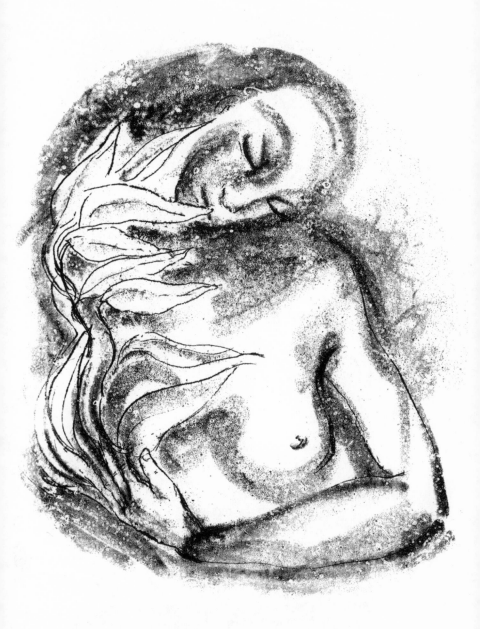

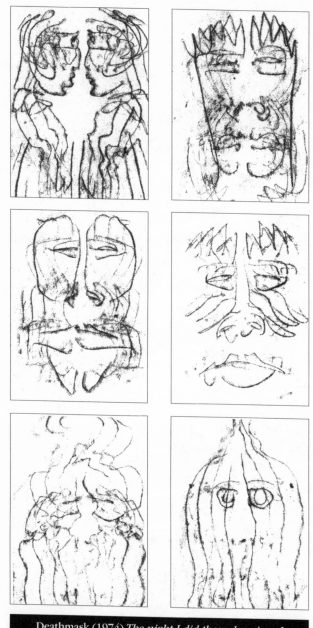

Deathmask (1974) *The night I did these drawings I thought I was going to die, but kept on drawing.*

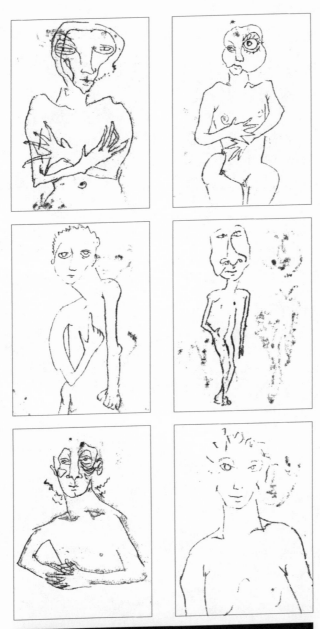

Uglies (1975) *I realized my drawings were portraits able to express and transform my self perception.*

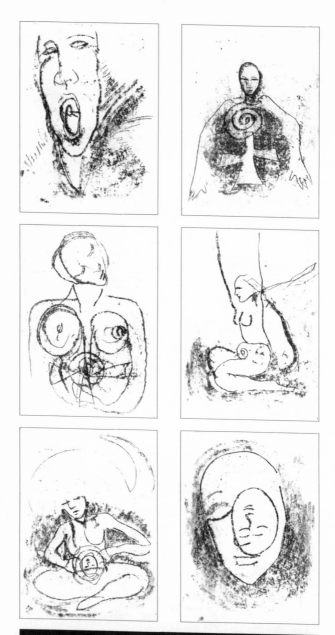

Birth (1986) *These drawings were done literally during the contractions of giving birth to my daughter.*

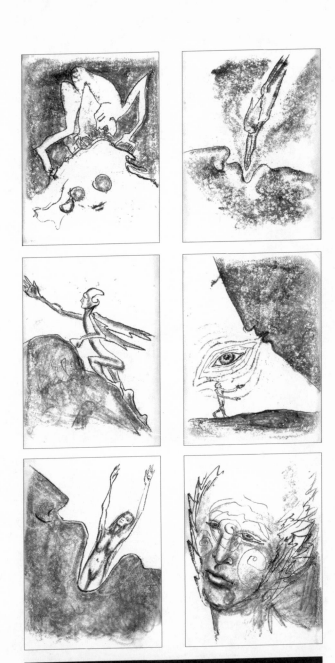

Dive (1995) *Over time, my Touch Drawing images have become more refined and their storylines more complex.*

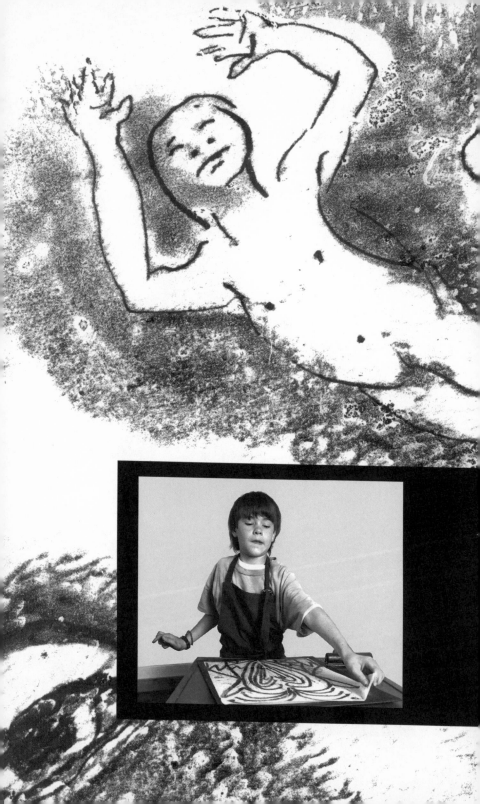

Resources

Learning Touch Drawing

Through The Veil:

The Story of Touch Drawing	Video	$29.95
European format	PAL	$39.95

60 minutes. This video begins with an in-depth demonstration of Touch Drawing. Through image, word and music, Deborah shares the story of its discovery, development, and use as a therapeutic tool.

Drawing Out Your Soul:

The Touch Drawing Handbook	Book	$8.95

50 pages. All the information needed to begin Touch Drawing, including detailed descriptions of materials, technique, personal and professional applications, and the story of its discovery and development.

Touch Drawing:

A Guided Experience	Audiotape	$11.98

90 minutes. Deborah gently guides the listener into a deep relationship with Touch Drawing, then continues with supportive music (drum, voice and chimes) for the duration. Recommended for use with the video or handbook. Includes basic written information on materials and technique.

Basic Touch Drawing materials (paint, paper, drawing board and roller) can be ordered through The Center for Touch Drawing. Please send a stamped, self-addressed envelope or call us for current stock and price.

We invite your feedback and stories about Touch Drawing! Please send photos and written material.

The Center for Touch Drawing
P.O. Box 914
Langley, Washingtom 98260
Phone: (360) 221-5745, fax (360) 221-5931
Email: touchdraw@whidbey.com
Web site: http://www.whidbey.com/touchdraw

Other Offerings

SoulCards $22.95
60 cards. Inspire your inner wisdom and creativity. Full-color images created by Deborah Koff-Chapin using the Touch Drawing method, with instructions for use.

At the Pool of Wonder: Book $16.95
Dreams and Visions of an Awakening Humanity
by Marcia Lauck and Deborah Koff-Chapin
113 pages. A work of creative synchronicity between Marcia's visionary dreams and Deborah's images. 22 full-color reproductions.

Voices From the Deep Audiotape $10.98
A musical collaboration CD $15.98
by Deborah Koff-Chapin and Anahata Moore
A rich soundscape weaving powerful vocals with ancient and contemporary musical instruments.

Goodbye Lullaby Audiotape $9.98
Deborah's heartfelt improvisational music, inspired by a deathbed vigil. Voice, chimes and dulcimer.

Full-color cards and prints of Deborah's Touch Drawings are also available. For information, refer to the SoulCard manual or contact The Center for Touch Drawing.

Ordering Information

Call (800) 989-6334 for placing orders only.

People at this number will not be able to answer questions regarding the process of Touch Drawing.

Orders may also be placed directly through The Center for Touch Drawing (see page 47).

20% discount on mixed orders of 10 or more items (except drawing materials).

Shipping and Handling Charges

Orders under $25.00 $3.95
$25.01 - $55.00 $5.95
$55.01 - $100.00 $7.95
$100.01 - $225.00 $11.95

Please call for express shipping.

Washington State residents add 7.9% sales tax.

International orders charged actual postage plus $2.00 handling. Please pay in U.S. International Money Order, VISA, MASTERCARD or DISCOVER.